salmon

The Blues

A Photographic Tribute

by

Ray Jeanotte

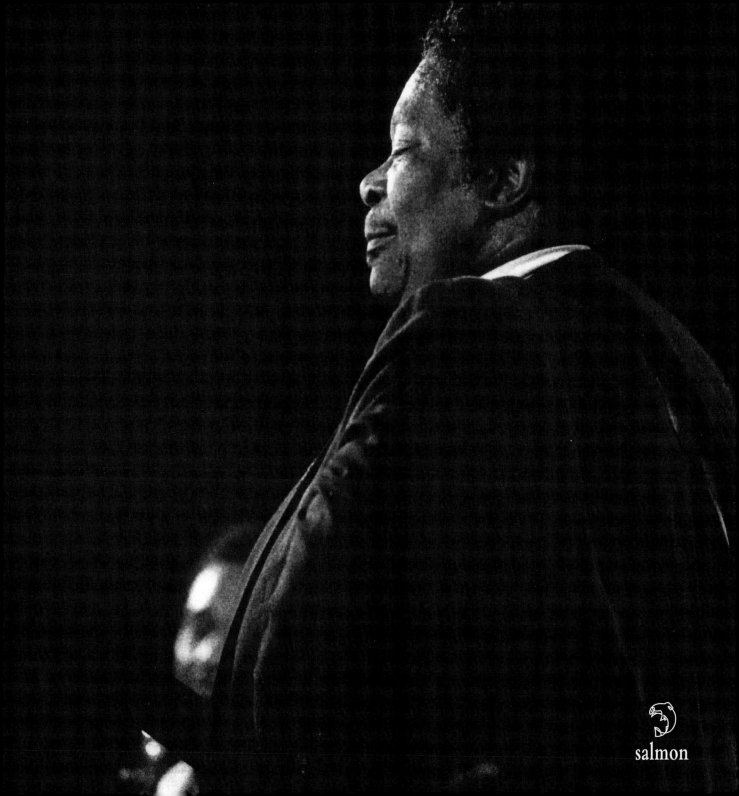

salmon

Published in 2014 by
Salmon Poetry Ltd.
Cliffs of Moher, County Clare, Ireland
Website: www.salmonpoetry.com
Email: info@salmonpoetry.com

ISBN 978-1-908836-77-9

COVER IMAGE: *BB King photographed by Ray Jeanotte in The Netherlands in 1996*
COVER DESIGN & TYPESETTING: *Siobhán Hutson*
Printed in Ireland by *Sprint Print*

To my family and friends and all blues players

Introduction

I fell in love with the blues hearing Jimmy Reed singing "Bright Lights, Big City." At that time, rock and roll was changing; losing its gritty edge. Eddie Cochran said it well with "Summertime Blues," a rockabilly classic. I grew up in the northeast of the US. There was a strong doo-wop and R&B scene, but we were deprived of the great rockabilly records. We had Bill Dogget's "Honky Tonk Part 1" which topped the R&B charts in 1956. Billy Butler's guitar licks and Clifford Scott's sax solo made it a masterpiece: Cool jazz cats inventing rock and roll. Doors were finally opening for black artists. Still, the record companies tried to feed us white artists like Pat Boone singing Little Richard, but no one could cover Little Richard. He made us dance! Finally, I found my way to The Apollo Theater in Harlem, New York. This was my first look at live bluesmen and I couldn't have found any better than BB King with T-Bone Walker.

The 1960s brought popularity to the blues. What had been called "race music" was now for everyone, via The Rolling Stones and John Mayall's Bluesbreakers, with Eric Clapton on guitar. We had some great players on this side of the pond, including Mike Bloomfield, John Hammond and Johnny Winter. Jimi Hendrix was still a few years off. Blues shows at venues like the Fillmore East and West were becoming more common. I attended a blues show at a club in Greenwich Village called the Café Au Go Go and I heard blues so powerful it stunned me: Son House, Skip James, The Muddy Waters' Blues Band and Paul Butterfield. I bought Delta Blues LPs by Robert Johnson, Blind Willie McTell, Memphis Minnie and anyone else I could find. Around that time I got a job at Young & Rubicam Advertising as a photographic assistant to Joe Eisenberg. Joe was a wonderful mentor and gave my life a new direction. He encouraged me in my own photography. I am honored to have taken photos of these great blues artists. Many have passed on, but their music still lives in our hearts.

Ray Jeanotte
Seattle, Washington

A Note from the Publisher

This book of photographs, taken by Ray Jeanotte from 1965 to 2004, brings together an eclectic mix of musicians who share a deep love of the blues and who have brought their own individual musical skill to bear on what is, arguably, the most deeply felt and meaningful of the musical genres.

The early part of the 20th century saw the first recordings of blues songs – this reflected its movement out of local communities in the South to the wider US. Early recordings by seminal greats like Mamie Smith and W.C. Handy served to build a blues following. In the 1920s, the blues developed an urban base, with singer/musicians, such as Bessie Smith, Gertrude "Ma" Rainey, Mamie Smith, Leroy Carr and Tampa Red, achieving renown. As with any grassroots music the blues has incorporated other styles over the decades and, indeed, made its own mark on many other genres. Obvioulsy, its close cousin, country music (also an expression of the deep south), moves in tandem and often forms a smooth merger. Jazz, rock and even pop, show blues markers, too. The musicians included here reflect this in their various ways. They have come from all types of backgrounds. Some learned their music as children, some later in life. All embraced the blues through the influence of other great musicans. The bluesmen and blueswomen in these pages contribute hugely to the canon of blues music and these photographs capture them at the height of their skill and passion.

This is the first book we've published that is not directly related to poetry. It is arguable, however, that blues is the poetry of musical expression; coming from a similar sensibility and awareness. Its origins reflect the struggle of individuals to come to terms with their place in the world, to lament, to find meaning in life; the necessary recognition of human solidarity in word and song, meaning and music. Indeed.

Jessie Lendennie
Editor, Salmon Poetry

Contents

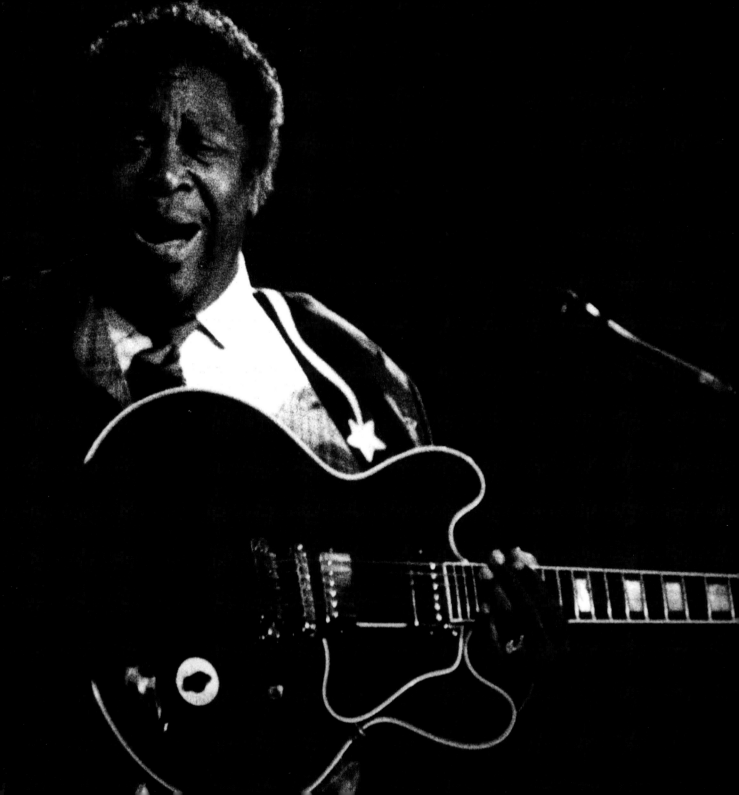

BB King

(1925)

I consider myself extremely lucky to have seen BB perform to a nearly all black audience at the Apollo Theater in Harlem, New York, in the early 60s. He played a show with T-Bone Walker. The Apollo was a movie theater and you had to sit thorough John Wayne movies and wait for the show to start. When it did it was incredible. I never went at night: the matinée price was more in line with my $35.00 a week income. BB and T-Bone put on a great show and played together and talked dirty to each other with their guitars. They worked the audience and the audience interacted in the same way they would with a pastor in church. It gave me goose bumps; being new to the blues I was blown away!

The next time I saw BB, I was armed with my trusty Nikon F and Tri-X film (I still have the contact sheets, but no idea where the negatives are). The gig was at the famous Fillmore East, with Mike Bloomfield and Johnny Winter. The Fillmore was sold out. The predominantly white hippy audience was turned on to the blues. The blues had been alive and well on the 'chitlins circuit' in the South, but it was rare to hear blues up North; with the exception of Chicago. The British bands, John Mayall and Cream and The Rolling Stones gave a rock and roll feel to the blues that helped to turn white kids into blues fans. BB King proved to the Fillmore audience that he was the real deal. Anyone who was lucky enough to be at that show saw history in the making.

The last time I got to see BB, was in Alkmaar, the Netherlands, in 1986. I was late getting to the show, which was held in an auction hall. I had to crawl through the crowd like a commando. I sat on the floor and shot upward. I got some of the best shots I have ever taken. BB put on a well-polished performance and got a standing ovation. After the show, I got in a long line of hopefuls looking for an autograph. I had a copy of the Charles Sawyer biography of BB that I hoped to get him to sign. BB came down the line and the crowd was overwhelming. Finally, he said, "Sorry folks, that was it." His valet was moving him off, then he noticed the book in my hands and said "Give it here." The next thing he said to me was, "your pen don't work." His valet whipped out a pen and BB signed the book. He, looked at me and asked, "Did you like it?" I said, "It made me feel like I know you personally." He gave that big BB King warm smile and walked on.

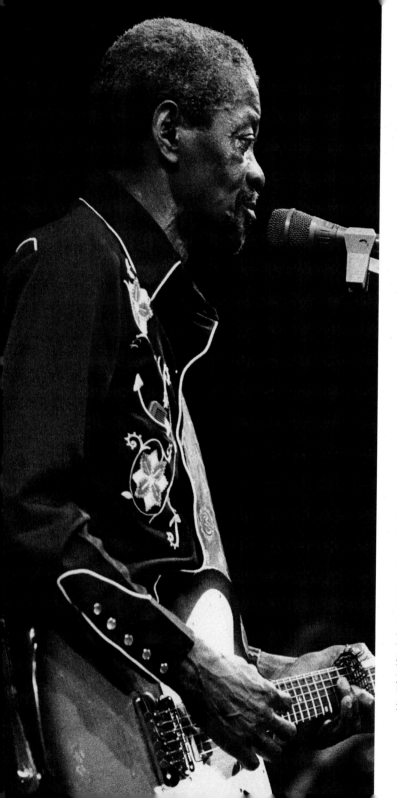

Clarence 'Gatemouth' Brown

(1924 -2005)

I first got to see 'Gate' in 1986 at the Dutch Annual Blues Festival in Amsterdam. Gate was the headline act. He was impressive, lean and dressed in a black cowboy outfit, smoking his pipe. It was a challenge to get a shot of his face, as the brim of his Stetson caused a shadow. After his first set was over I headed to the bar for a beer. Gate's bass player was at the bar and I struck up a conversation and asked him if he thought Gate might remove his cowboy hat for a few shots. "No way," he replied, "but I'll tell you what – pick up my scotch and soda and I will get his hat off." True to his word, he tilted the headstock on his Fender Bass and off came Gate's hat! Five years later I caught the band in Seattle, at a club called The Backstage. He played a masterful show, and the cowboy hat stayed intact. He was signing copies of his new CD and I waited in line to buy it. I had a few prints from the Amsterdam show, so I handed him a photo and he looked at it for a while and then looked up at me. I thought he was about to bite my head off about the hatless photo, but he looked sad, "Boy, I sure miss that guitar." His guitar had recently been stolen. I said he could keep the photo. He offered to pay for it, but I wouldn't let him. "It's an honor for me to give it to you, but there is one favor you could do for

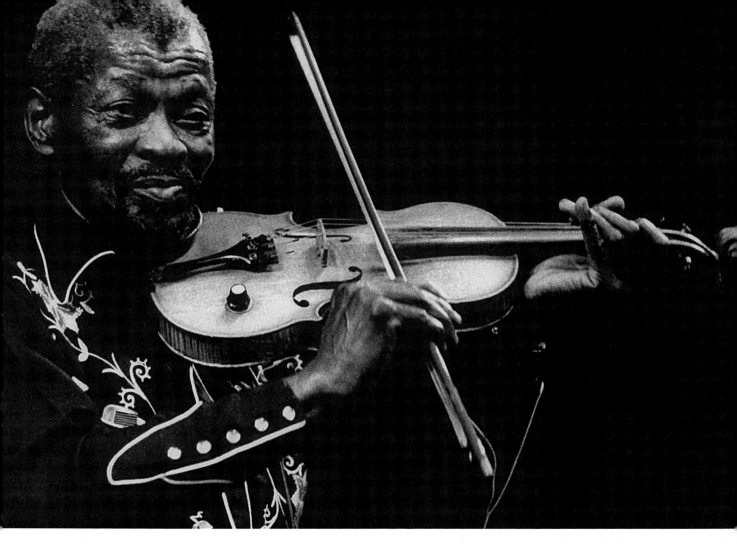

me." "What?" he replied. "Could you show me that Texas style turnaround?" "No, I don't give guitar lessons." By this time the club was cleared out. Gate paused… "Aw, shucks, let's go get my guitar. I'm only going to show you one time." He did it nice and slow and I got it. I had tried for years to play that lick. I went to bed with a smile on my face! The last time I saw him play was at Seattle's Bumbershoot Music Festival. He looked frail and was in the last stages of cancer. He passed away in Texas at his sister's home. He had just lost his home to Hurricane Katrina. That last show was very moving. He played great swing tunes, including "Take the A Train," Duke Ellington's "C Jam Blues" and a very moving version of "Over The Rainbow"; not to mention an ample dose of pure blues. Gate was a multi-instrumentalist and was as comfortable playing blues guitar as he was playing Cajun fiddle, jazz and country. His fans all over the world will miss him. As I do. I feel very lucky to have seen him perform. God bless his soul.

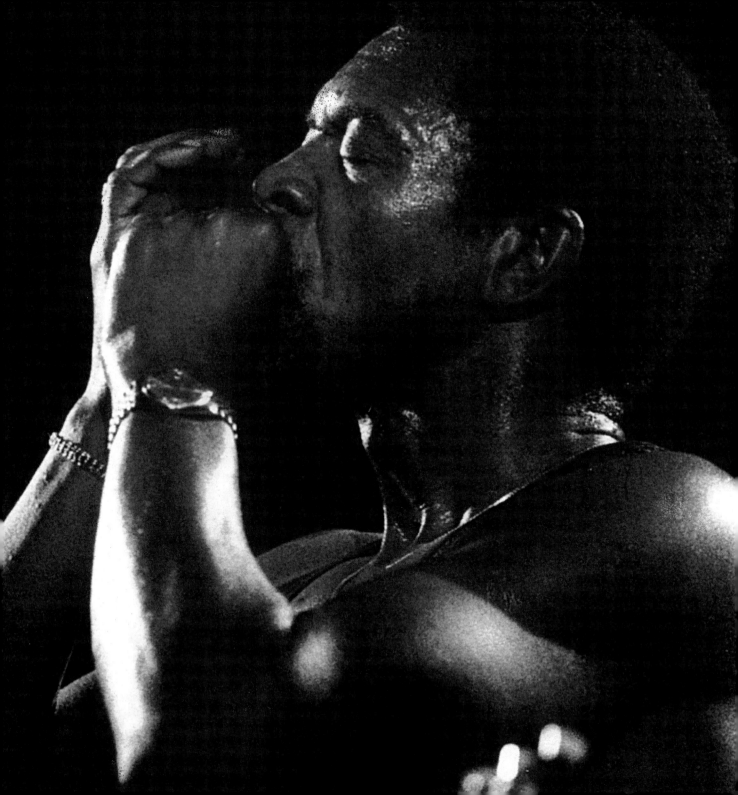

Luther Allison

(1939 - 1997)

I was able to see Luther Allison, backed up by his French band, at Amsterdam's Paradiso in 1988. I found a staircase that led to a balcony and I was able to set up my tripod and be in line with the stage. I got some good shots. Luther sang the blues and played guitar and harmonica with authority. The band did a fantastic job that night. I was moved by his performance. Luther settled in France in 1977 and enjoyed playing all over Europe. It wasn't until the early 1990s, and a recording contract with Alligator records, that he moved back home. He often toured, backed by The James Solberg Band, and very quickly developed a loyal fan base. The album "Soul Fixin' Man" was recorded in 1994. Sadly, Luther passed away in 1997 from a heart attack, but he made a powerful statement by winning four W.C. Handy Awards. Luther's son Bernard Allison carries on the family name and records and tours. He can be seen at blues venues worldwide. The song "Cherry Red Wine" is a very powerful blues song, dealing with alcoholism and its effect on a family. It was released on the LP "Blue Streak" in 1995.

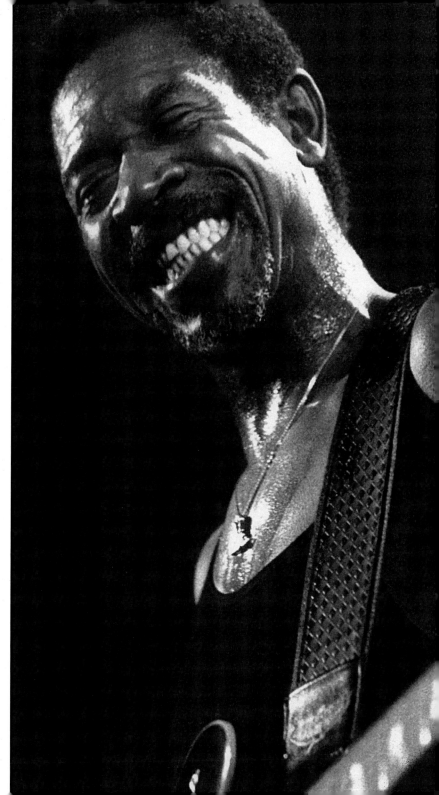

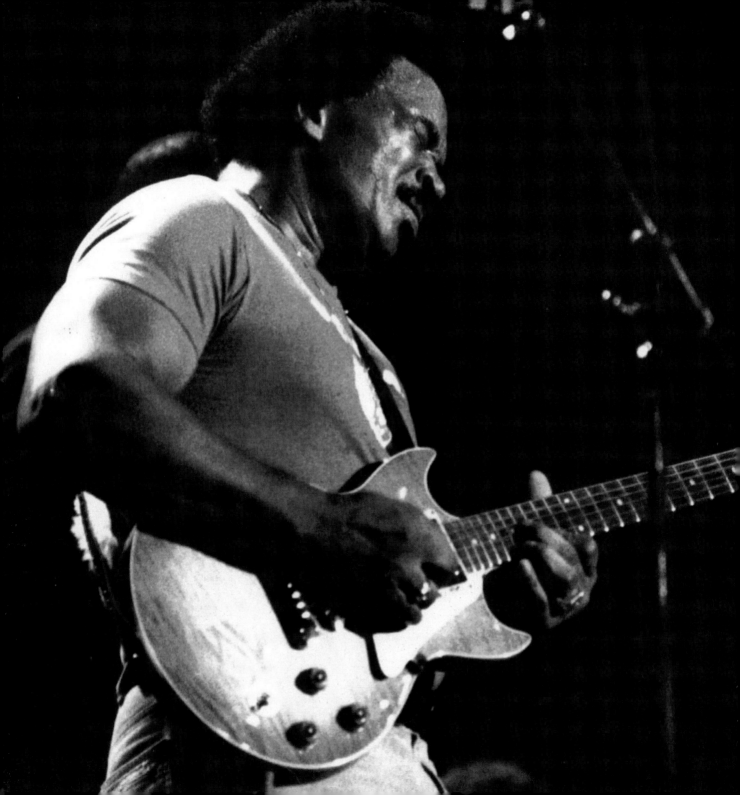

Matt 'Guitar' Murphy

(1929)

What blues fan can forget Murphy for his role in *The Blues Brothers* films: *The Blues Brothers* (1980) and *Blues Brothers 2000* (1999)? He played the role of Aretha Franklin's hen-pecked husband. It you haven't seen these films, check them out; great fun! Murphy joined The Blues Brothers band in 1978. The band included the Stax Records' rhythm section musicians Steve Cropper and Donald Duck Dunn, along with Murphy. I saw him play at Amsterdam's Blues Festival in 1988. His guitar work was Chicago style all the way. The band was tight and he easily won over the audience. He kept time with his eyebrows – very cool! Murphy spent years backing up other blues greats, including James Cotton, Willie Dixon, Memphis Slim, Etta James and Howling Wolf. He didn't have his own band until 1982. He suffered a stroke in 2003 while performing in Nashville, but he still does the occasional tour.

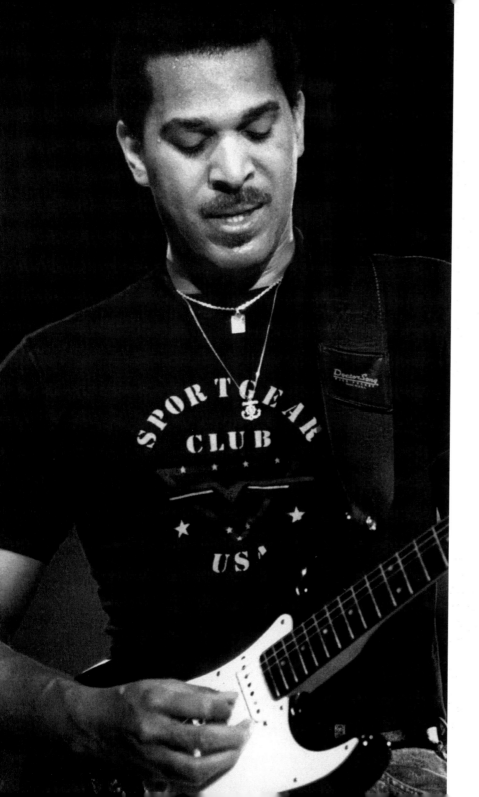

Melvin Taylor

(1959)

Melvin Taylor has been on the blues scene for many years. He was influenced by BB King, Albert King, and Stevie Ray Vaughan. Unlike most bluesmen, Melvin is equally at home doing jazz gigs. He was raised on George Benson and has even opened shows for Benson. Melvin also holds Wes Montgomery high on his list of favorites. Melvin has a huge following in Europe and toured with The Slack Band. He has recorded some great blues, and has recently recorded gospel music. Taylor was born in Jackson, Mississippi. His family moved to Chicago when he was three years old. He grew up surrounded by the great Chicago bluesmen. He was playing gigs by the age of eleven. Taylor has a huge fan base in Europe; I shot this session in Belgium in 1988. He has great stage presence and knows how to entertain a crowd!

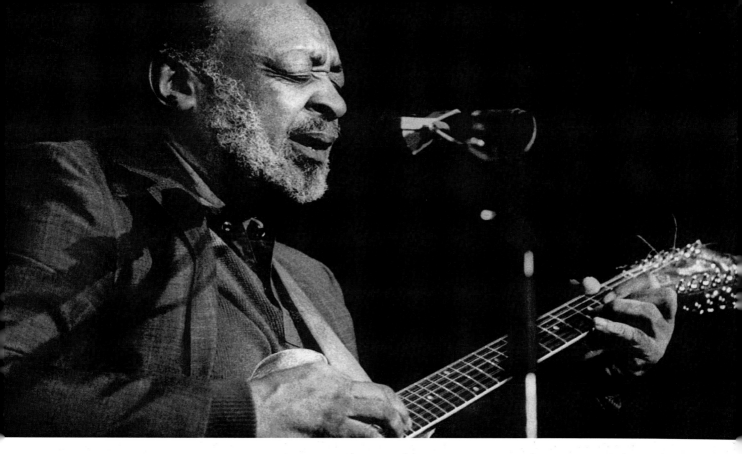

Robert Lockwood Jr.

(1915-2006)

Robert Lockwood Jr. was born in the town of Turkey Scratch, Arkansas, and spent his youth on the Mississippi Delta, before heading north to Chicago, and later to Cleveland. I knew that he was a fabulous rhythm guitarist and had played on the Chess and Checker recordings of the great Little Walter, one of the finest harmonica bluesmen to ever lay it down. Just listen to the early 1950s recordings of "My Babe" or "Mellow Down Easy" – some of the best post-war blues to ever be recorded. Then I got to see him play in Amsterdam at the Dutch Blues Festival in 1988. He played a rare solo performance, doing lots of Robert Johnson material and I found out very soon why he is called Robert Jr. His mother and Robert Johnson had lived as man and wife for ten years. Robert Jr. learned his guitar licks from the source, but he sang with a softer voice. The sound was haunting. If you ever wondered what Robert Johnson would sound like on an electric guitar, check out Robert Lockwood Jr. He put intense feeling into each tune. I had the feeling that Robert Johnson's spirit was in the room that night in Amsterdam. I was able to get some great shots at this show and Robert didn't bounce around too much. Just a steady rolling man! No pun intended!

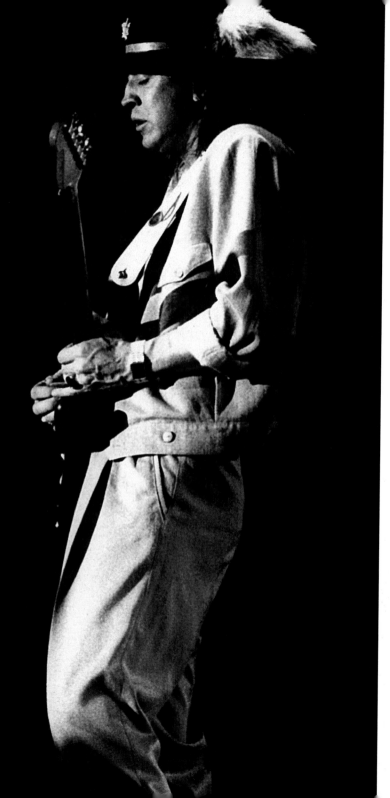

Stevie Ray Vaughan

(1954-1990)

When blues fans and MTV fans were buzzing about Stevie Ray Vaughan, I felt guilty for not having heard of him. Who is this guy? I did know of Jimmie Vaughan, Stevie's older brother and a member of the Fabulous Thunderbirds. Then, one of my guitar-picking buddies handed me an LP and told me to go home and listen. I loved Stevie's flashy guitar licks and great blues voice. I played the LP deep into the night, over and over, and when I handed it back the next day it was well worn! I didn't get a chance to catch him live until 1988, at the Peer Rhythm and Blues Festival in Belgium.

The word going around was that he had been messed up with substance abuse problems and had not finished his 1987 European tour. No one knew what to expect.

He walked out on stage and gave his sincere apologies to the audience for his 1987 "lackluster shows." "I am going to make up for it

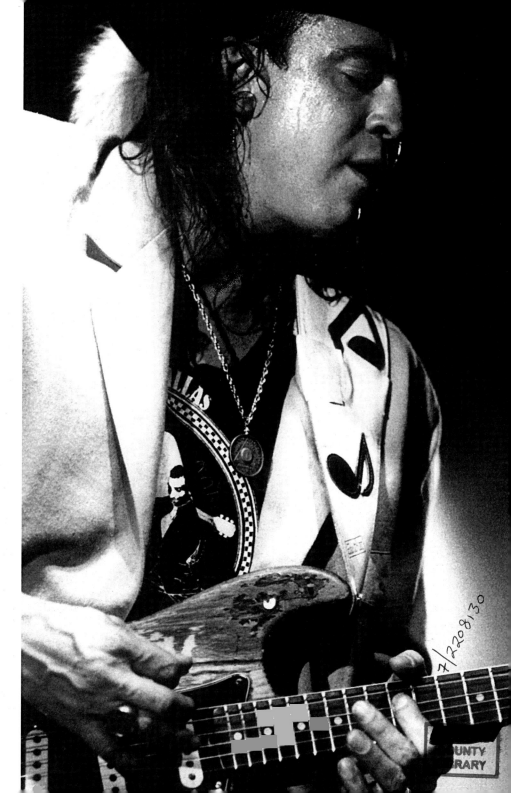

tonight," he assured the audience, "I am clean and sober and I will do my best." The band was in killer mode as they started in on "Pride and Joy" and Stevie let loose with a vengeance on his famous SRV Fender Stratocaster. I saw the show through my cameras lens. I have never seen such passion; his facial expression, flying fingers and guitar tone were to die for! He was back on top form. Tommy Shannon, his bassist, was beaming at Stevie. Seeing all this unfold from just a few feet away left me speechless. Stevie played for what seemed like two hours. The crowd was stomping and shouting, "We want more!"

When I got the news about the helicopter crash and Stevie's tragic death, I was upset; so much so that I had to leave work early. I got home and looked through my photos and wept. Out of respect, I never tried to sell my images. I thought someday they might be included in a book. There are some great videos available of Stevie's live shows: The Austin City Limits is a great one. Please, if you love the blues, check them out.

21

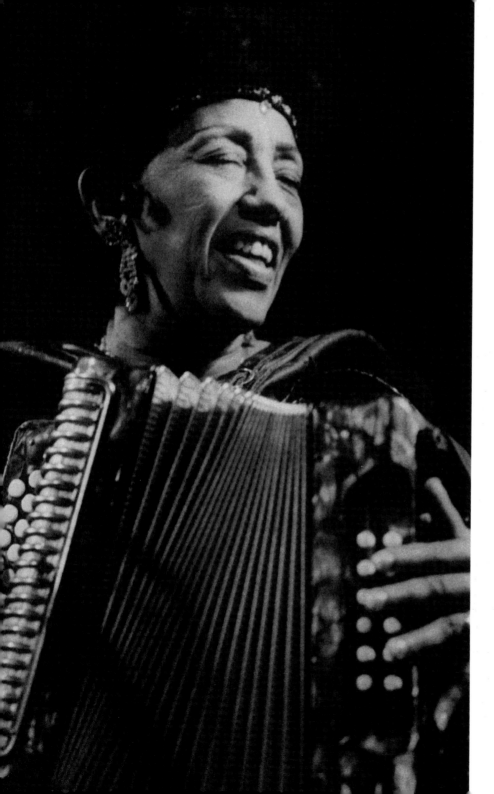

Queen Ida

(1929)

Queen Ida was born in Lake Charles, a French-speaking part of Louisiana. Her family moved to Beaumont, Texas and then eventually to San Francisco. Music was an important part of the family tradition and Ida learned to play the accordion from her mother. In San Francisco, the family met other Cajun and Creole families and they would cook Cajun style and play music together. Ida started playing with bands in the early 70s; initially with her brother Al's group, The Barbary Coast Band, and later with The Playboys. The Barbary Coast Band changed its name to Queen Ida and The Bon Temps Zydeco Band. Zydeco music has elements of R&B and blues-country, played through a French filter – to blend a real musical Gumbo! I saw the Band at Amsterdam's Paradiso, an old church converted into a great concert venue. The Dutch audience loved the Zydeco sound and threw themselves into the Cajun two-step to 'Jambalaya'. Hashish fumes filled the hall; adding to the mind-blowing experience!

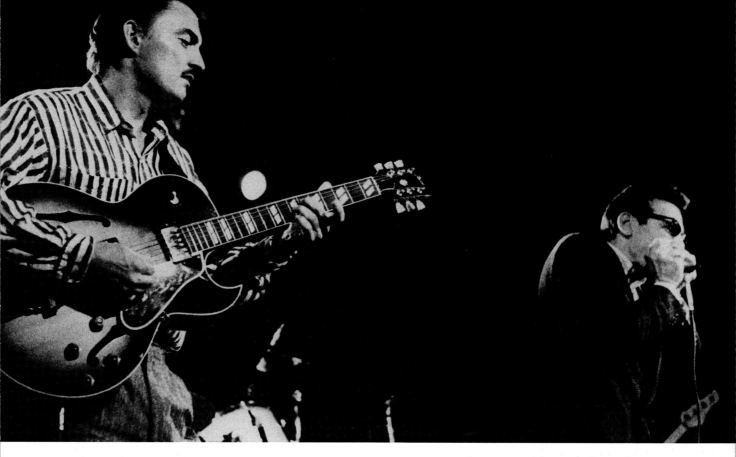

Charlie Baty

(1953)

As the legend goes, Charlie Baty got into music playing harmonica, then switched to guitar. Man did he ever – Baty is a monster on guitar and has mastered most styles: jazz, blues, soul, swing and rock. He almost never plays barre chords; he applies more sophisticated alternate jazz chords in a blues setting. He was influenced by the styles of Robert Lockwood and Charlie Christian. In 1976 he met Rick Estrin and formed Little Charlie and the Nightcats. I knew about the band while I was still living in The Netherlands and I looked forward to seeing them play in Seattle. I did not have to wait very long, I saw them in 1989 at the Backstage. I talked a bit with Charlie that evening. To my surprise, he took the time for his fans and was happy to talk about guitars. I had just bought a Gibson ES175, the same model that Baty himself plays. We were instant friends. He mentioned that I should check out Jimmy Bryant; great advice! Little Charlie and the Nightcats toured for many years. When Baty decided to retire from the band, Rick carried on as 'Rick Estrin and the Nightcats'. Charlie is still recording and doing some online teaching. The Nightcats recorded over ten CDs, all of which are worth the price.

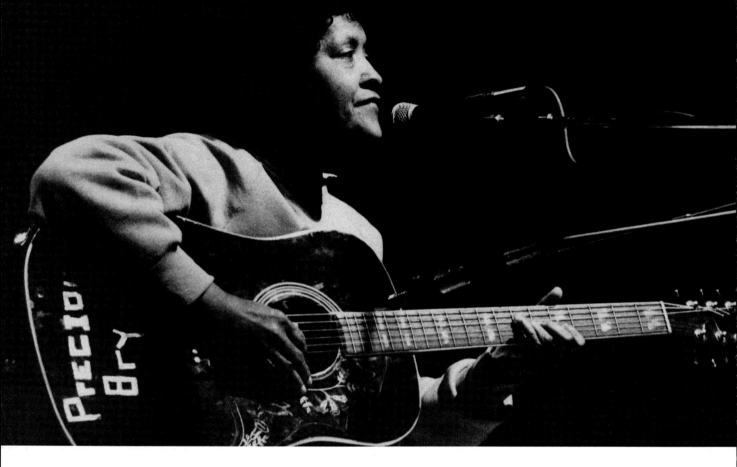

Precious Bryant

(1942)

Precious Bryant was born and raised in Talbot County, Georgia. As a young woman, she learned to play acoustic finger-style guitar in the Piedmont tradition. Her influences include Blind Willie McTell and Blind Boy Fuller, and female blues greats such as Memphis Minnie and Ma Rainey. I was lucky to see Bryant in Seattle, at The Folklife Festival in 1989. I had not heard of her before and was very pleased to see this great artist perform. She had a gentle, soft voice and a skilful command of her guitar. I knew I was seeing the real deal. Bryant has two recordings available – "The Truth" and "Fool Me Good". She also did a wonderful gospel-style tune "Morning Train." A real foot tapper!

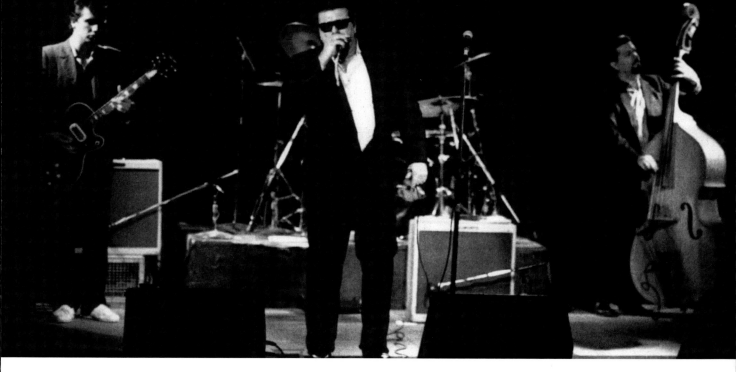

William Clarke

(1951-1996)

William Clarke was one mean-blowing harp man! He played both cross harp and chromatic, the "fat sounds" made famous by the irrepressible Little Walter back in the 1950s. Clarke was a student of the west coast harp man George Smith and played with Smith from 1977 until Smith's death in 1983. Clarke's approach to the blues was driven by his pure dedication. Alligator Records signed him in 1990 and his debut "Blowin' Like Hell" was released that year, followed by "Serious Intentions." My first and only opportunity to photograph Clarke was in 1991 at the Backstage Club in Seattle. He put huge energy into his show; he was sweating profusely and let the music out like a shockwave. The audience were on their feet throughout the entire show. I found a good spot in the rear of the club and got the whole band in, by stagelight. Clarke left us a great legacy of fine recordings, but I wish everyone could have seen this show!

25

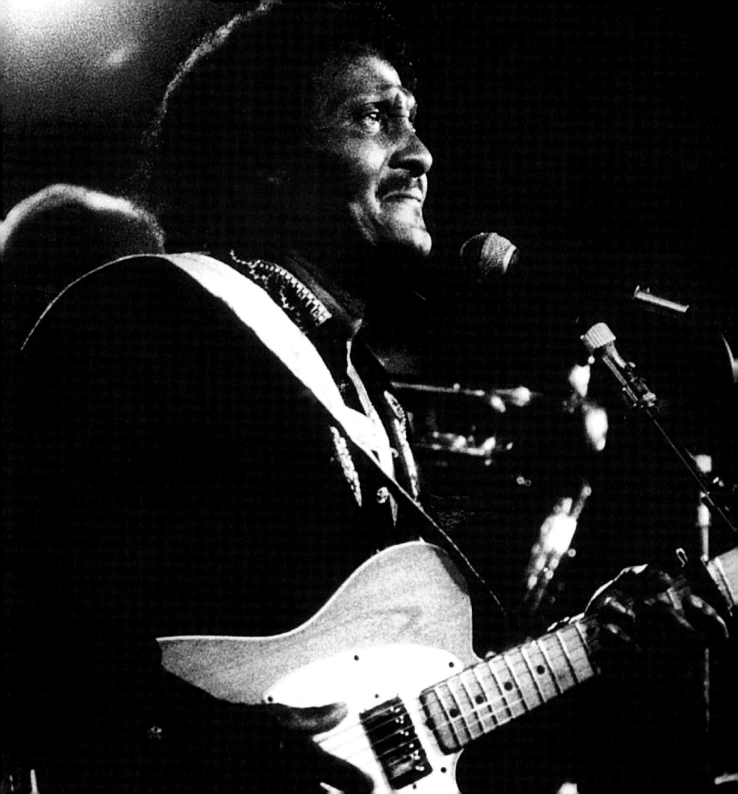

Albert Collins

(1932-1993)

Shortly after arriving in Seattle in 1989, I had a front row chance to photograph the one-and-only Albert Collins, "Master of the Telecaster," at Seattle's Backstage Club. He worked hard on stage; sweat was pouring down his face. He played like no other guitarist, in open tunings, and made great use of his capo. That night he tuned his guitar to an f# minor chord and used his capo to change key. His guitar sound can only be described as sassy! Among his recorded work is a great live LP with a dutch band, Barrelhouse, with Tineke Schoemaker, a fine Dutch female blues singer. The CD is hard to find, but worth looking for. Albert did some great instrumentals, like "Frosty" and "Conversation with Mr. Collins." The latter is a story about his wife staying out until four in the morning, and it's very funny. Albert died at sixty-one years of age. He was in a class of his own. One of my favorite tunes is "I ain't drunk, I'm just drinking". His guitar work is awe-inspiring. And the words are a hoot!

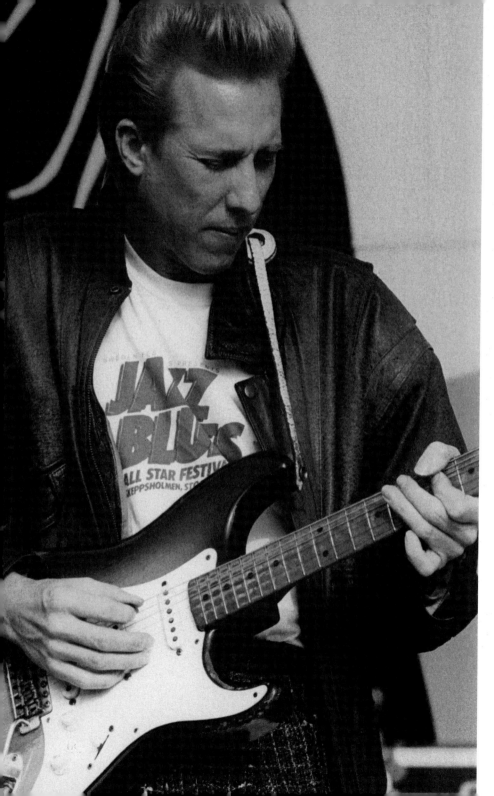

Anson Funderburgh

(1954-)

Anson Funderburgh was born into the Texas shuffle playing style. He grew up seeing one of the guitar greats, Freddie King, and was drawn to Jimmy Reed's shuffle sound. His career started with his band Anson and the Rockets, with lead singer Darrell Nulisch. Black Top Records signed them and they were an instant hit with blues fans all over the world. Texas was giving Chicago a run for its money as the place to make your name. Antones in Austin was booking the best acts: Buddy Guy, Albert Collins, and the Texas crowd which included Stevie Ray Vaughan and The Fabulous Thunderbirds, with Kim Wilson and Jimmie Vaughan. Anson and the Rockets fit right in. Darrell Nulisch, decided to head out on his own in 1984. Anson called on his friend Sam Meyers to be the band's new front man. This turned out to be a fantastic move. Sam

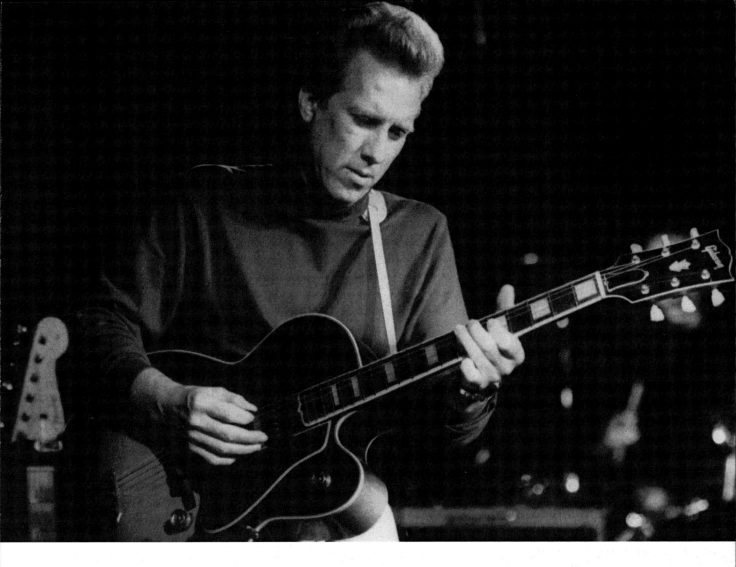

was a great singer and a master harmonica player. The band looked great on stage, Sam with his harp in one hand and a cigarette in the other and Anson laying down his great guitar licks. Sadly, Sam passed away in 2004, after twenty years with the band. Anson was heartbroken, as was the band. Everyone acknowledged that blues history had been made. I got to see them three times and they were great to photograph, especially Anson with his 1957 Stratocaster and his Gibson archtop Jazz Box.

Duke Robbilard

(1948)

I first read about Duke in Guitar Player Magazine in 1984. There was a flexi-disc in the centerfold of the magazine featuring a jam between Duke and Jimmie Vaughan. I wore it out in no time! I finally found an LP "Duke Robillard and the Pleasure Kings" – a great, enjoyable record. I was living in The Netherlands at the time. Duke was unknown in Amsterdam, until he did a Sunday night show at the Paradiso. There was a small audience, but it was made up of Dutch blues guitarists. After the show, Duke was invited to a jam at the Melo Melo blues bar a few blocks from the Paradiso. The bar smelled like beer and hashish. He got up on stage with some Dutch guys and, dressed like a Wall Street stockbroker, blew the roof off the club. Duke was a founding member of Roomful of Blues and later replaced Jimmie Vaughan in The Fabulous Thunderbirds. He has recorded with jazz guitarist Jim Hall and Bob Dylan on "Time Out of Mind" and made a guitar lesson DVD on T-Bone Walker. T-Bone Walker's influence can be heard in Duke's playing. Duke is a blues singer and can belt it out with the best of them. If he never sang a lick, he would have made it on his guitar chops alone. But, we are lucky he did sing!

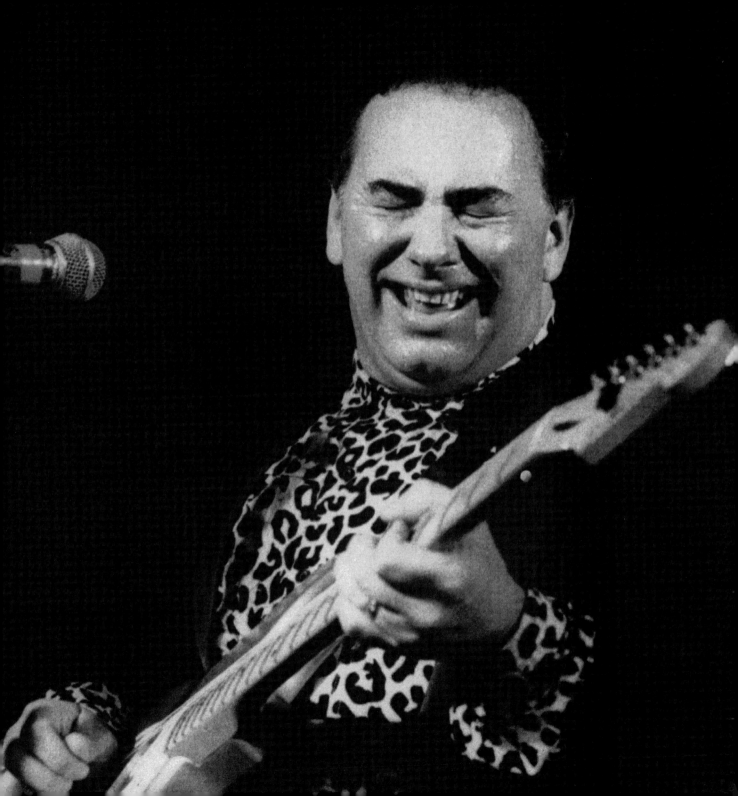

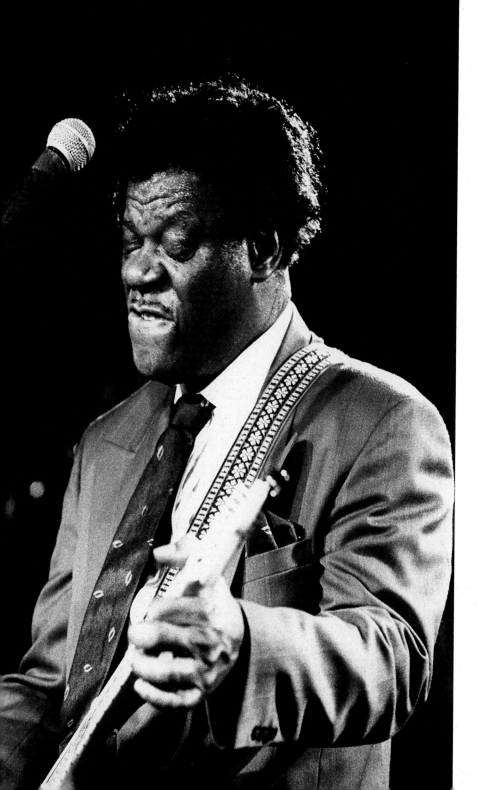

Earl King

(1934-2003)

Earl grew up surrounded by music; his father was a blues piano player in New Orleans. Earl was a fan of Guitar Slim (Eddie Jones) and later worked with Slim. Slim's influence can be heard in Earl's guitar style. Earl worked with most of the major New Orleans singers and players. He recorded with the great Huey 'Piano' Smith and His Clowns. He played on such hits as "Rocking Pneumonia" and "Don't you just know it" in the 1950s. Earl's first hit came out at that time, "Those Lonely, Lonely Nights". An excellent example of New Orleans Style. I saw Earl in 1990 at the Backstage Club in Seattle. I was on my way to the men's room and saw Earl headed into the ladies' room, a little bit on the tipsy side. I was able to stop him just in time and pointed him to the men's room – wondering if he could play in his condition. He kind of stumbled up on the stage and then, as if a switch was turned on, he put on a great show; one that I will never forget. He was backed by one of the Pacific Northwest's best bands, "Lloyd Jones Struggle" from Portland. He wore a red suit and had his trusty red Stratocaster. Earl went on to record for Alligator Records and did some fine work with "Room Full Of Blues". It was great to see him get some recognition from a younger fan base. His death, in 2003, was a tragic loss to his many fans.

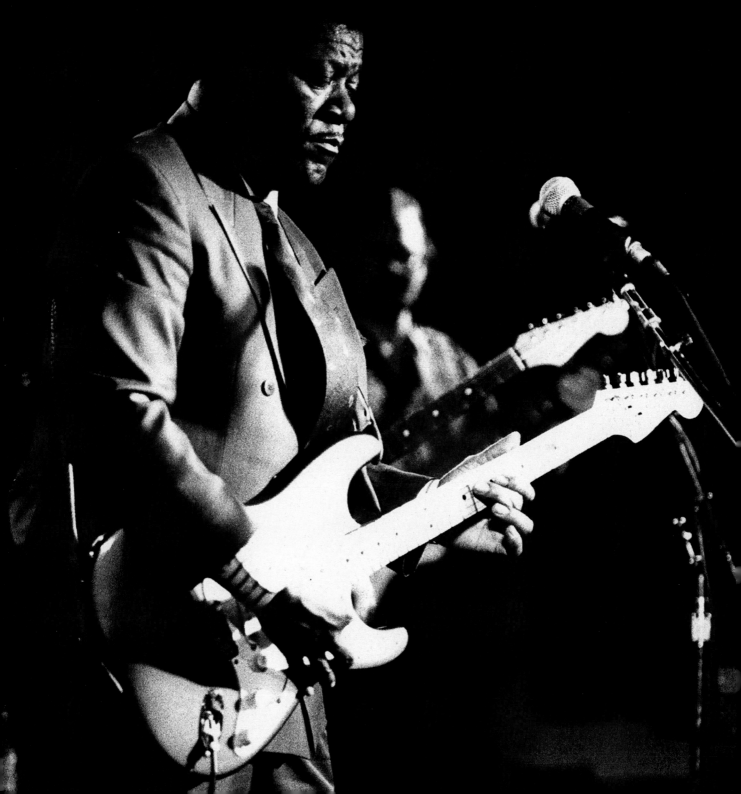

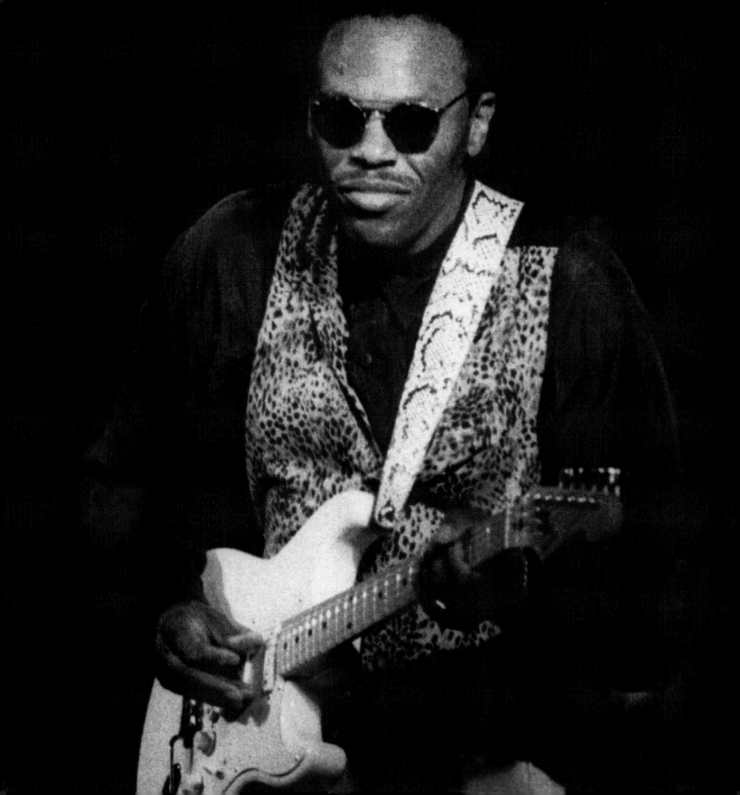

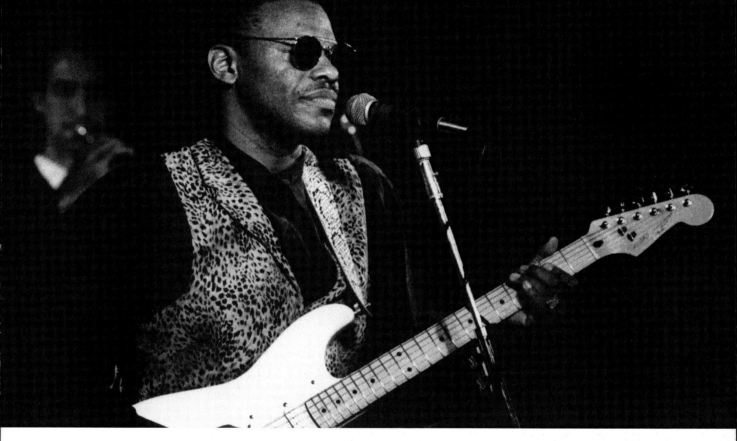

Joe Louis Walker

(1949)

I first heard of Joe, when I lived in The Netherlands. I saw a vinyl copy of "Cold As The Night", Joe's first Hightone LP. I bought it on the chance that I would like it. I dug Joe's blue Stratocaster that he was holding on the cover. I played a blue Stratocaster myself at that time. The LP was a real find. R&B - blues; very soulful, with killer guitar licks, not to mention Joe's great voice! He was born and raised in San Francisco and was influenced by BB King, T-Bone Walker and Freddie King. In the 1960s, Joe lived in a house with Mike Bloomfield of The Paul Butterfield Blues Band. I'm sure Mike's playing made an impression on Joe. I first saw Joe play in Belgium in 1988. He had to follow Stevie Ray Vaughan (no easy task!) at the Peer Rhythm and Blues Festival, and he hit a home run with his tasty chops. I saw him again in Seattle and he had matured and developed. Not only can he play electric guitar, he can play Delta blues on the acoustic guitar, and can lay down some great slide licks. He has since done some fabulous recordings and has played and recorded with Duke Robillard.

Katie Webster

(1936-1999)

Katie earned the nickname Swamp Boogie Queen while backing up Excello artists like Lighting Slim and Lonnie Brooks. She later backed Otis Redding. She was pregnant at the time of the air crash that killed Otis and most likely not part of that last tour. She was devastated by the loss of Otis and the band and gave up music for a time. She bounced back in the early 1980s and began a series of tours to Europe. Her European fan base was huge. I didn't get to see her during my twenty years in Europe, but I finally had the chance in Seattle during a Fat Tuesday celebration at Pioneer Square's New Orleans Cajun Café. The line for the show wrapped around the block, despite the fact that it was a frosty night. A big white stretch limo pulled up and out stepped Katie, like the queen she was. The crowd cheered. At last the doors opened; we were out of the cold and into Katie's world. She let loose with her piano-beating boogies and just mesmerized the audience. Her happiness at playing her music warmed her fans like a cozy fireplace. When she did "Two Fisted Mama" it was heaven! Katie passed away in 1999, due to heart failure. I am so glad I got to be at that show. I love this photo, it's totally Katie. God bless her.

Lou Ann Barton

(1954)

Lou Ann Barton has been singing the blues since the early 1970s. She has worked with some of the very best Texas blues artists, including Stevie Ray and Jimmie Vaughan and WC Clark. She sings her heart out on stage and puts herself into each tune with passion and style. An Antones, of Austin, regular, she has toured with Antone's Women. I caught up with her in Seattle on a tour in 1991 that featured, as well as Barton, Angela Strehli, Sue Foley (a last-minute replacement for Barbara Lynn) and Toni Price. The backing band featured Derek O'Brien on guitar, one of the best guitarists on the Texas scene. Barton was everything I expected; a powerful voice with Texas cowgirl charm. She brought Austin to Seattle!

Sam Myers

(1936-2006)

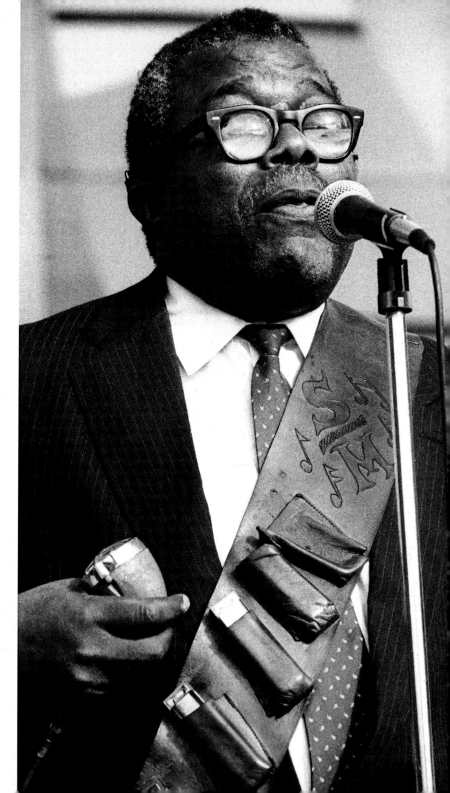

Sam Myers had an incredible talent as a singer and mouth harp player. Born in Mississippi, he suffered juvenile cataracts at age seven and was visually impaired for the rest of his life. In 1952, while at the American Conservatory of Music in Chicago, he started playing drums for the great slide guitarist and singer Elmore James. He played mouth harp on "Look Over Yonder's Wall," one of Elmore's best-loved tunes. In the early 1960s, Sam returned to Mississippi and remained in Jackson until hooking up many years later with Anson Funderburgh. Anson was introduced to Sam while he and The Rockets played in Jackson in 1982. Sam sat in with the band. Sam and Anson became great friends and when Anson's front man, Darrell Nulisch, left to go on his own Anson called on Sam. Sam had a great sound as a frontman. His experience gave authenticity to the band. The band stayed together for the next twenty years. They won W.C. Handy Awards and turned out some great recordings as "Anson Funderburgh and the Rockets, featuring Sam Meyers". Sam and Anson made a fine song-writing team. The song "Highwayman" tells Sam's life story. He was a legend and I feel blessed to have seen him in action.

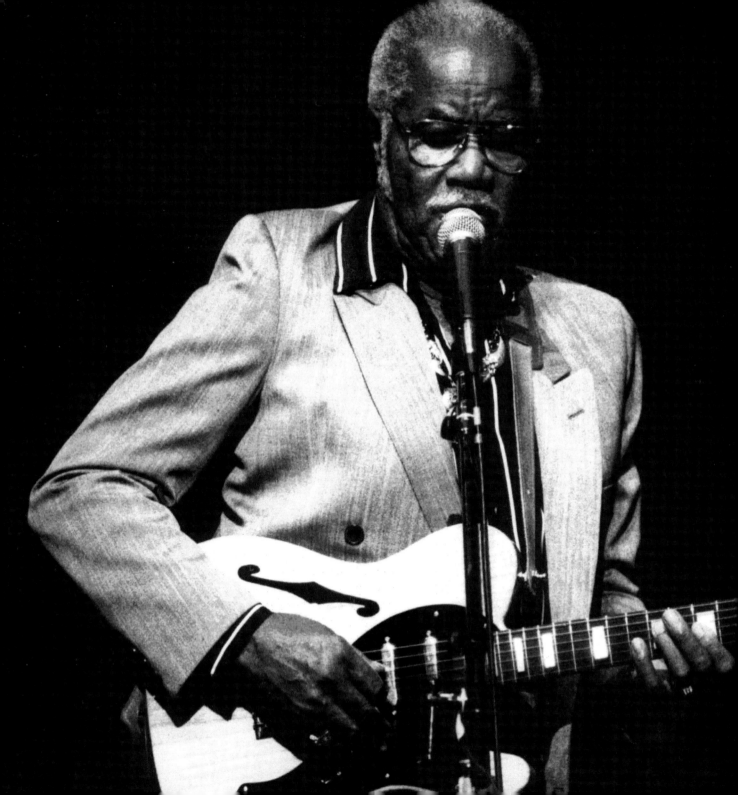

Roebuck 'Pop' Staples

(1914-2000)

Roebuck 'Pop' Staples was born on a cotton plantation in Winona, Mississippi. He learned to play guitar as a boy by watching Charlie Patton on the nearby Dockery Plantation. He saw many of the great Delta bluesmen, including Son House and Robert Johnson. He turned to gospel music, but never got the blues out of his mind. You could say that he played for God in a bluesy style! He settled in Chicago in 1936, with his wife and children. He was blessed with very talented children: Mavis, Cleotha, Yvonne and Pervis. They formed The Staple Singers in 1948; one of the most famous gospel/pop crossover groups ever. They had a number one hit with "Respect Yourself". The Rolling Stones did a cover of The Staples' "This Must Be the Last Time " – changing the title to "The Last Time". I would love to know what Pop thought of it!

In 1969, I was at a very historic show at the Fillmore East: Janis Joplin headlined, with The Staple Singers as opening act. They invited Janis to sing with them. The Staples looked like angels in white choir robes, and Janis was a contrast with her hair, wild and flowing! It was really a hoot! This photo of Pop was taken at the Seattle Opera House in 1991. He did a great version of Blind Willie Johnson's "Nobody's Fault, But Mine" that included some great solo guitar work on his Telecaster.

Tinsley Ellis

(1957)

Tinsley Ellis was born in Atlanta in 1957 and raised in Florida. He took up guitar at the age of eight. He was impressed by British bands of the 1960s: Cream, The Yardbirds and The Rolling Stones. This lead him to "the three kings of the blues guitar": BB King, Albert King and Freddie King. Ellis started playing in bands in 1975. I picked up on his playing in Holland, from his first LP "Georgia Blue." I admired his approach; a hard driving guitar and a powerful voice. He played a great show in Seattle in 1992. I remember him doing the show-stopping instrumental, "Mercy Mercy Mercy," a jazz/soul classic. It was recorded live by Cannonball Adderley in 1966. Ellis has recorded five albums for Alligator Records and is playing shows all over the USA and Europe. The tune "Devil For A Dime," from the LP "Storm Warning," is Ellis at his best.

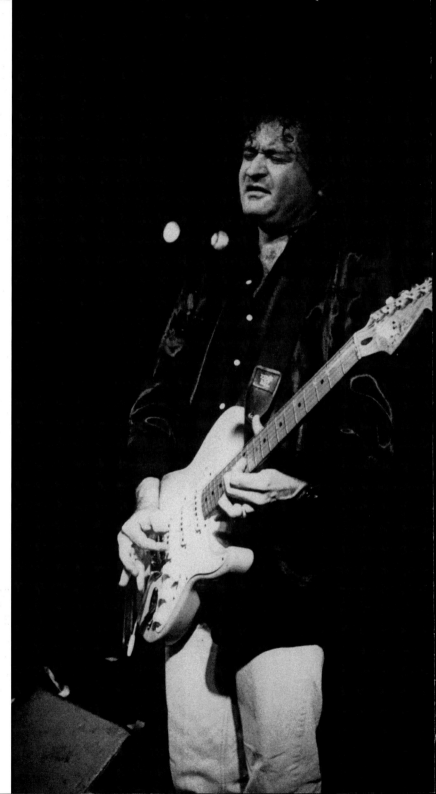

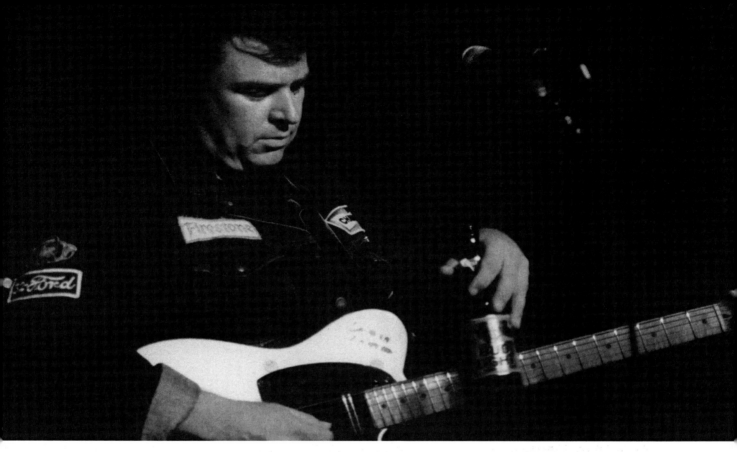

Danny Gatton

(1945-1994)

Danny Gatton played jazz, blues, and rockabilly, a style he liked to call Redneck Jazz. His heroes were from the early days of rockabilly: Scotty Moore, guitarist for Elvis Presley, and Cliff Gallop with Gene Vincent. He was a jam buddy with the late Roy Buchanan. Roy was a tone master on the Telecaster and was asked to join The Rolling Stones, an offer he turned down. Danny loved the blues and developed an overhand style of playing slide guitar. He liked using a full bottle of Budweiser for the tone. He can be seen on Austin City Limits playing an amazing rockabilly medley of Elvis's Sun Record tunes, Junior Parker's "Mystery Train" and Arthur Big Boy Crudup's "My Baby Left me" and "That's Alright Mama". Danny's guitar work on this medley shows why they called him "The Humbler". Widely admired and respected by his peers, he was yet referred to as "the greatest unknown guitarist" by Guitar Player Magazine. Danny left us with some really fine albums. "88 Elmira Street" stands out as one of the best. I saw Danny at The Backstage Club in Seattle. I was able to get my camera up front and got Danny playing beer-slide guitar. Sadly, Danny could not deal with life and shortly after being dropped by Elektra Records took his own life.

John Hammond

(1942)

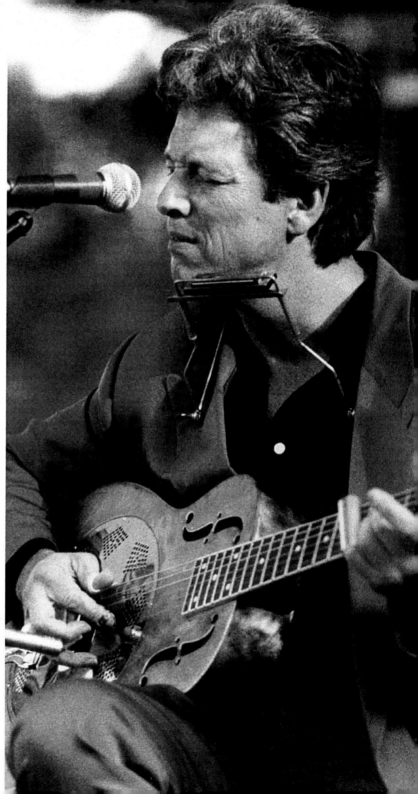

John P. Hammond is one of the finest stand-alone bluesmen on this planet. He has dedicated his life to the blues. He arrived in Greenwich Village in the 1960s and played at the Gaslight Café, gigging with a band, and on his own. He did an LP for Vanguard that featured tunes of Robert Johnson and Blind Willie McTell. He played a National Steel guitar and blew harmonica, using a neck-brace, in the style of Jimmy Reed. He plays authentically and with authority. I got to talk with him a few times at a bar called Saint Adrian Company in New York City. I remember talking to him about his playing on the soundtrack to the movie "Little Big Man." His guitar and harp work during the credits set the perfect mood for the film. I found John to be humble, and kind of shy. He could have been a rock star, but he chose to focus on his real love, the blues. He has never taken advantage of his famous dad, John Hammond Jr, a CBS Artists and Repertoire man best known for the talent he discovered, including Bessie Smith, Bob Dylan and Bruce Springsteen. John gained a wider audience with his brilliant CD of Tom Waits' tunes, "Wicked Grin." In recent years, John has written some great songs himself. One of my favorites is "Slick Crown Vic." He got the idea for the song after seeing a Ford Crown Victoria on a used-car lot in LA. It was love at first sight. This photo was taken at Seattle's Bumbershoot Fair in 1993.

Lil' Ed Williams

(1955)

Ed Williams was born in Chicago into a blues family. His uncle JB Hutto taught him to play slide guitar when he was a child. Hutto was a follower of Elmore James. James was the first blues slide guitarist to play Delta blues on the electric guitar. He was followed by Muddy Waters, Hound Dog Taylor and JB Hutto. Ed and his brother Pookie, on bass, formed their first band, The Blues Imperials, in 1975. They've done a great job holding up the family name; still going strong after thirty years. I saw them at an outdoor show in Seattle on a very warm summer afternoon. The audience was melting in the sun. When Ed and the boys began to play the crowd came alive. Ed jumped into the audience, guitar and all. He even did the limbo, while banging out slide licks. High-energy and great fun to watch! "Hold that Train" from the LP "Full Tilt" starts with a barrage of wicked slide licks.

45

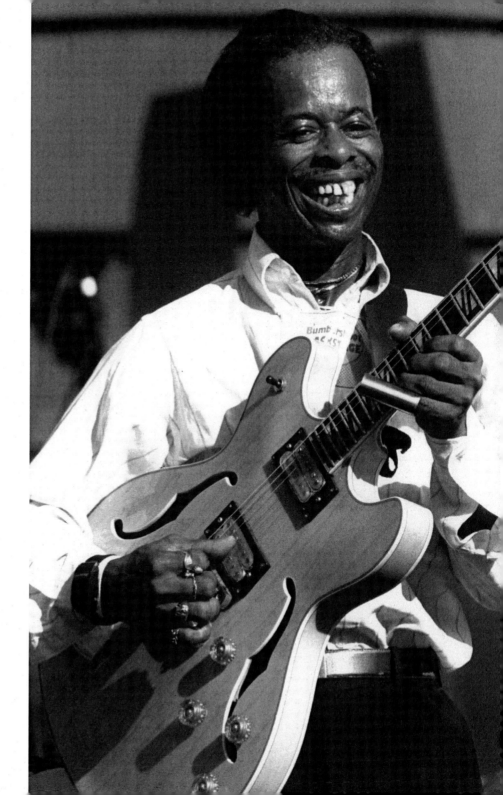

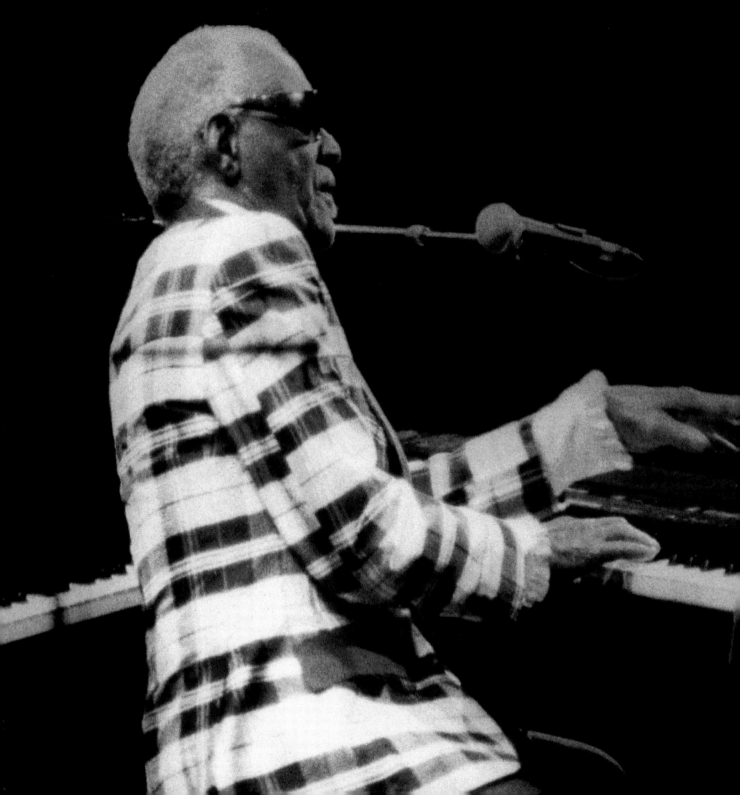

Ray Charles

(1930-2004)

What can you say about Ray Charles? I think John Sebastian of The Lovin'
Spoonful summed it up best: "It's like trying to tell a stranger 'bout rock 'n
roll" (from the Spoonful's hit "Do You Believe in Magic"). Ray was pure
magic and, indeed, a genius. He could do anything: gospel, rock, blues,
soul, country and a healthy helping of jazz. He was also a master lyric-
writer. Mix that all up, and you had Ray. His piano playing was as exciting
to listen to as his soulful voice. He ruled the radio in the 1950s and 1960s.
His sound was truly the sound of the city. I would have loved to see Ray
and The Raelettes perform and hear the call and response sound in "What'd
I Say" or the vocal battle in "Hit the Road Jack." Even Elvis Presley's great
version of "I Got a Woman" didn't hold a candle to Ray's. I'm very glad that
I got the chance to get shots of Ray in concert. My nine-year-old son was
with me that day. To him Ray was the Pepsi Cola guy from the TV ad, and
that was really cool. The show was held in the Seattle Sonics arena and the
sound-echo bounced off the walls. Ray was not happy about that, but he
was fantastic despite the sound problem. "Georgia on My Mind" gave me
goose bumps. To quote Ray himself: "I don't want to be famous, just
great." That, he was.

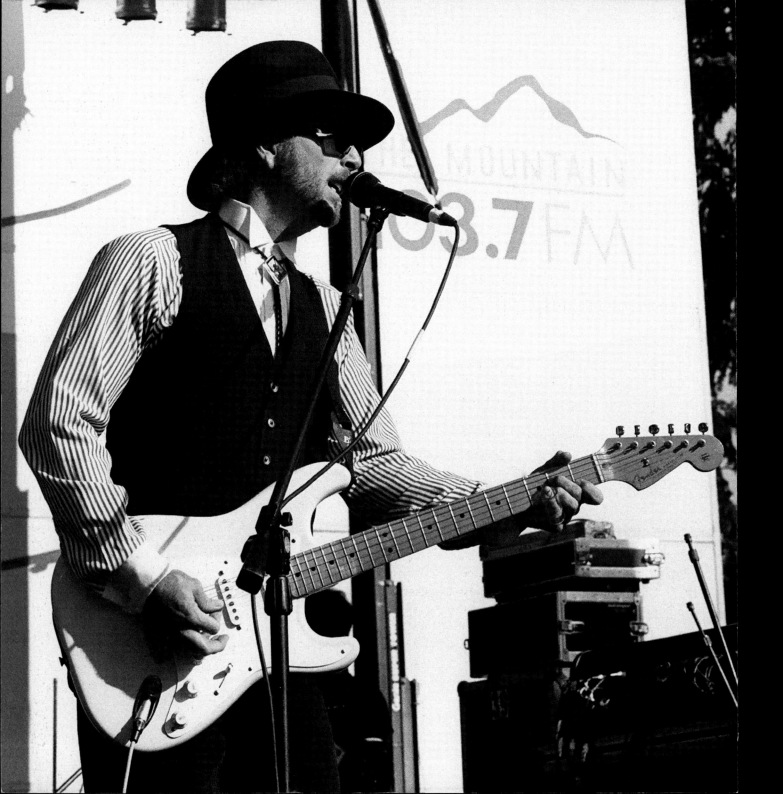

Roy Rogers

(1950)

Roy's slide playing is so authentic that it's said, "He could peel a crawfish!" He started playing in rock bands in his teens in and around the San Francisco bay area. His older brother turned Roy on to Robert Johnson and that began a new direction; one of dedication to the Delta blues. Roy got a chance to work with John Lee Hooker and spent four years with John's band Coast to Coast.

His first album was titled "Chops Not Chaps," very fitting as Roy was named after the cowboy legend of the 1940s and 50s.

I saw Roy for the first time at an outdoor lunch concert at Seattle's Westlake Park. He was joined by Norton Buffalo. Roy played an acoustic guitar and Norton blew mouth harp. Some sweet down-home Delta blues! The next time I saw Roy was on the blues stage at Seattle's Bumbershoot Festival and I had my trusty Nikon with me. Roy was backed by his band The Delta Rhythm Boys. There is no-one like him on slide, he was playing an acoustic electric and it gave off a powerful tone. The band was great and dynamic. Roy's slide guitar work was incredible. He did a rousing version of Robert Johnson's "Walking Blues"; winning him a standing ovation!

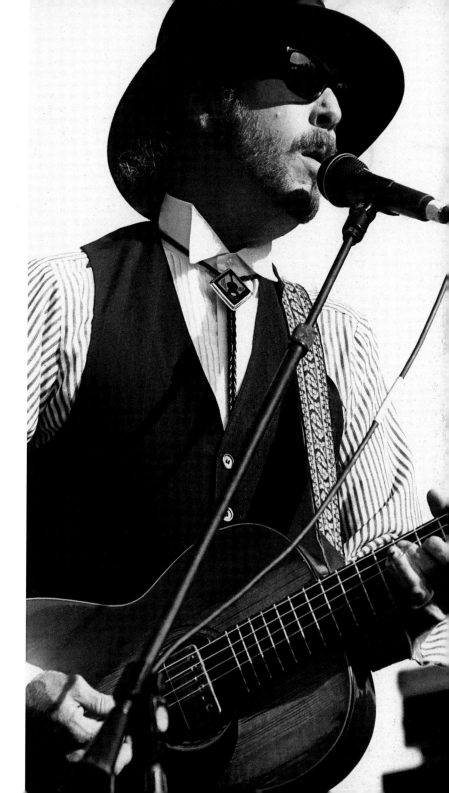

Otis Rush

(1935)

I have always admired Otis Rush's guitar style. He is one of the most polished bluesmen I have ever heard; indeed, one of the finest living blues artists in the world. He plays his cherry red Gibson ES345 left-handed. No chance to steal any licks! He writes his own songs, and his mellow voice and understated chops form a perfect harmony. I had tried to see him perform several times in Europe and in the States, but always missed him by a day or two. Then, I was in Chicago to do a shoot and to my great joy Otis was playing at Buddy Guy's Blues Club on Wabash. I couldn't believe my luck, and it was even more special to see Otis in Chicago – his own town! I had my Leica M6 and some high-speed T-Max film. It was a very low-light club, so I leaned against a pole and hoped for the best. I shared a table with some very cool locals and an old buddy of mine from Seattle. It was a night to remember. I can only describe the show as hypnotic and string bending!

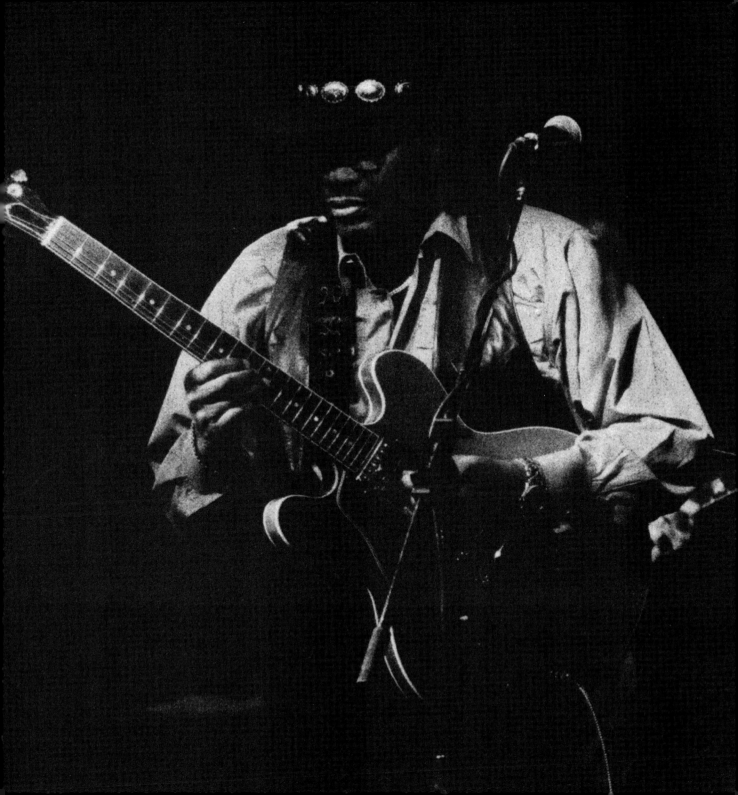

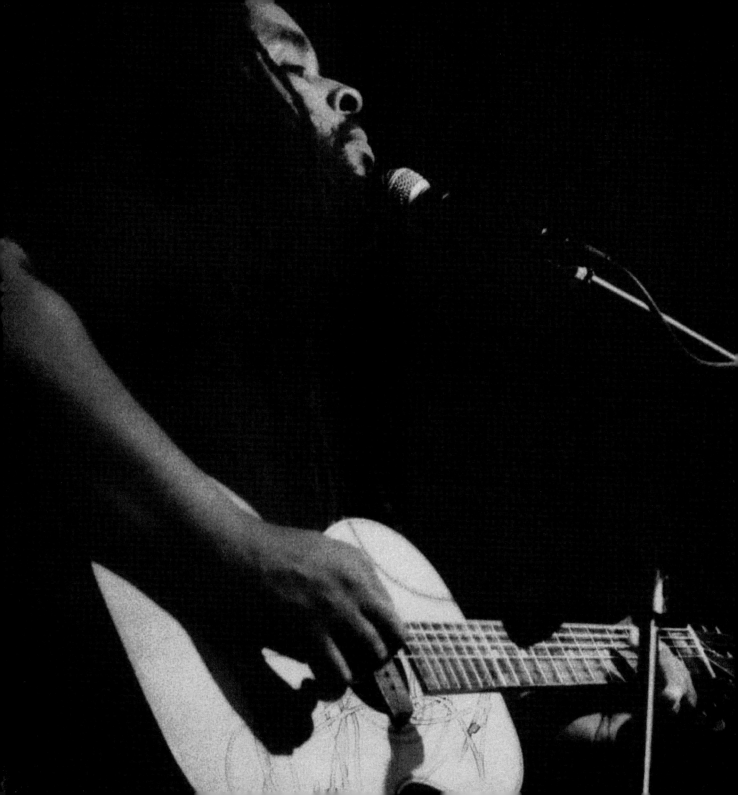

Alvin Youngblood Hart

(1963)

I first became aware of Alvin Youngblood Hart when I saw his first CD "Big Mama's Door" in a record store. The cover showed a photo of this cool-looking guy with dreadlocks, playing a vintage-looking 12-string guitar. I had a birthday gift-card and took a chance, letting my instincts guide me. I loved it! The title track really moved me. Hart has a powerful voice and is a killer guitar player; his country blues is amazing. He is a true 'roots music' man and can do soulful tunes as well as blues; he won a Grammy for his version of Stephen Foster's "Beautiful Dreamer" on the CD "Songs Of Stephen Foster". He became a friend of Taj Mahal and has recorded with Taj. Taj said of Hart: "That boy's got thunder in his hands." I saw Hart for the first time in Seattle's Trading Musician vintage guitar shop. I had a ticket to see him at Seattle's Jazz Alley that very evening. I talked to him briefly as he was about to purchase a vintage amp. His first gig in Seattle was terrific and I got some good shots. I saw him again in Tacoma's Jazz Bones Café and again at Jazz Alley, paired up with Guy Davis. Hart played a very cool National Steel guitar, a banjo, and his vintage 12-string. He did " Big Mama's Door" on the National Steel. The sound was haunting!

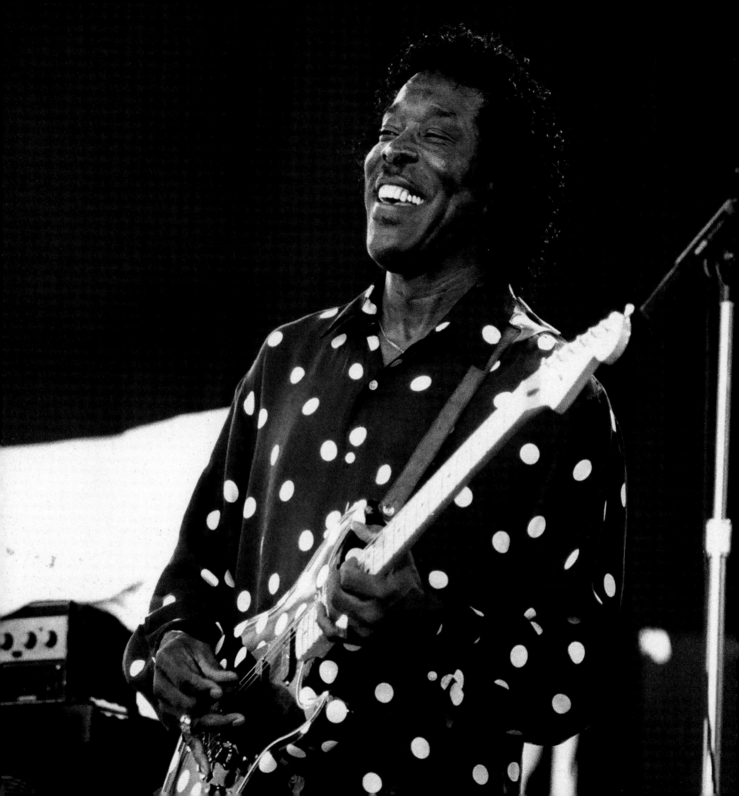

Buddy Guy

(1936)

Buddy spent his boyhood in Lettsworth, Louisiana. While still in his teens he played for Excello Records, backing up artists like Slim Harpo. He hit Chicago in 1957 at the age of twenty-one. He worked a day job doing auto-repairs. He met harmonica man Junior Wells in 1967 and they developed a great sound together on the Chicago scene. They played The Fillmore East and West for mostly white audiences and things began to happen. Buddy was a big influence on Eric Clapton and Jimi Hendrix. The 1980s brought about a huge blues revival and Austin, Texas, was the hot, happening town; with Stevie Ray and Jimmie Vaughan and bands like the Fabulous Thunderbirds, Buddy was playing big venues. His music was starting to sell as he went solo.

Buddy is a master showman and blues guitar virtuoso. He has joy written all over his face on stage and makes the crowd feel special – like he is letting you in on a really good joke. His use of dynamics is like whispering the lyrics in your ear. I saw him at the Paradiso, in Amsterdam, with Junior Wells, in 1987 and they were outstanding. Junior would do a lick on the harmonica and Buddy would answer on the guitar. The photos taken here are at Seattle's Bumbershoot Festival. He was playing to a younger audience; grunge fans. Buddy is so much fun, he just blew them away: "Who says I can't play rock?" he yelled, as he broke into "Purple Haze". He did Jimi proud. The big hit of the show was "Damn Right, I Got the Blues". Yeah!

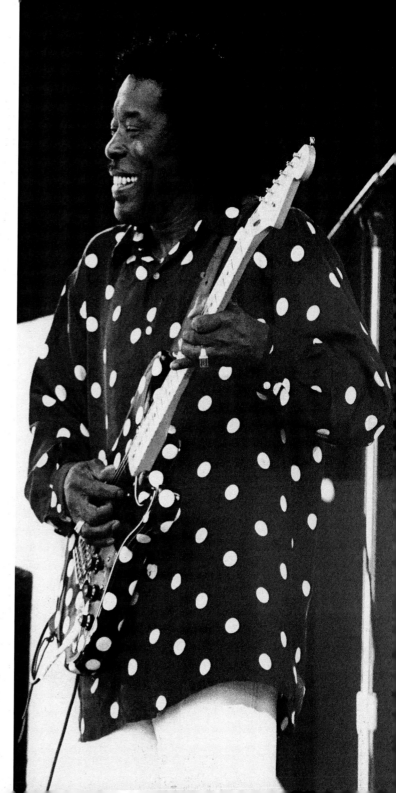

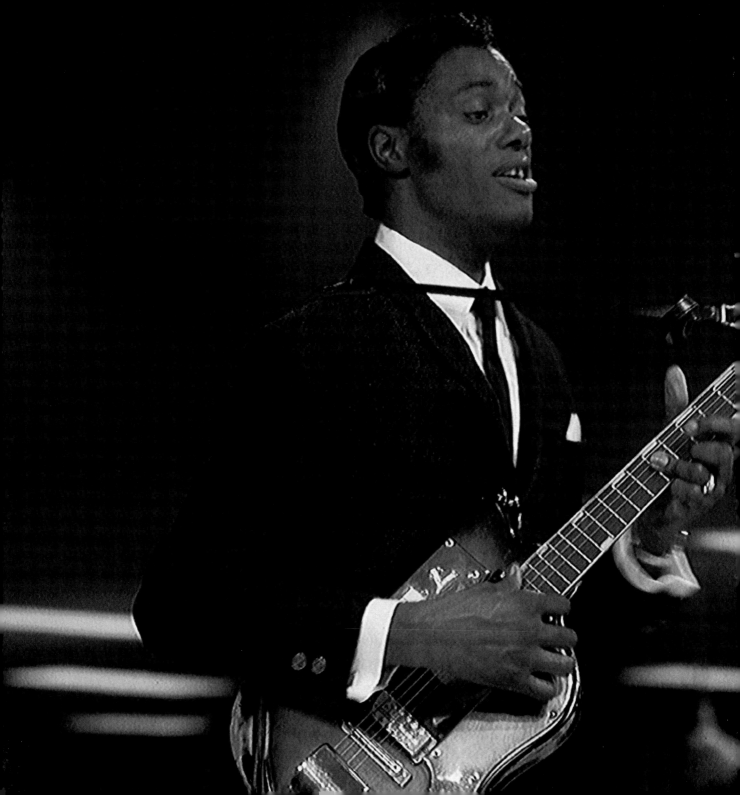

Who is he?

I've spent many hours of my time trying to solve the mystery of this bluesman's identity. I took this photo at the New York World Fair in 1965. The film I used was Tungsten Color Slide, suitable for shooting in artificial light, since I had been taking night shots of the fairlights. At one point that evening, I poked my head into a café where this bluesman was playing, and took this photo. By looking at the type of guitar he was playing, and the unique way he was using his thumb, you would think that would narrow the field of blues musicians. He had a great sound playing this style. I've asked everyone I knew from Portland, Oregon to Vancouver, British Columbia and they all had the same response: "He looks really familiar!" However, no-one could put a name to the face. I remembered another show I'd shot in New York City and thought he might have opened for The Lovin' Spoonful. I asked a friend of mine, Marc Bristol, who publishes a great roots music magazine, *Blue Suede News*, if he could help. I gave him a copy of the photo. Marc was kind enough to send the photo to John Sebastian of The Lovin' Spoonful. John didn't know, but he sent a copy to Steve Boone, and also to Jimmy Vivino, the great guitarist on The Conan O'Brien Show. Jimmy thought that it could be Johnny 'Guitar' Watson because of the way he held his guitar and used his thumb. If it was Johnny, the photo was taken before he adopted his afro hairstyle. I've looked at all the photos I could find of Johnny and none of them look like the man in my photo. I was hoping some kind reader might see this and help me solve the mystery. I think it is too cool a photo to leave out of this book. Thanks for any possible help and to all the people who have given their help along the way.

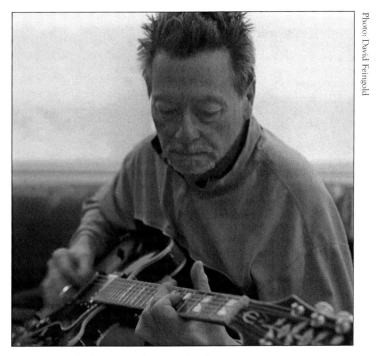

As a young photographer in the late 1960s, **Ray Jeanotte** worked with many famous photographers in the vibrant New York scene. He learned to play the guitar at an early age, and later played in various clubs around New York City. In 1970, he graduated from the prestigious School of Visual Arts with a degree in photography. He then spent twenty years in Europe working as a freelance photographer and musician. His work has appeared in a variety of publications including *Can-Am: Photo History* by Pete Lyons, *Time and Two Seats* by János Wimpffen of Motorsport Research Group and Mark Donohue's book *The Unfair Advantage*. One of his favourite commissions was providing the artwork for Ray Bradbury's *I Live by the Invisible: New & Selected Poems* (Salmon Poetry, 2002). Ray currently teaches portrait lighting workshops in the Washington area.